THE ARTWORK STYLINGS
OF
MARK A. SIMPSON

BY: Tabatha M. Simpson

&

BY: Mark A. Simpson

This book could not have been created without help from a few others.
With that being said, I feel I must thank the following:

Tabatha Simpson (My Younger Sister),
She is the soul backbone behind the development of this book.
If it werent for her the ideas and thoughts that went into this book,
would have never been developed.

CreateSpace,
Thanks for giving me the means,
materials
and tips for turning my artwork into something much more.

Debbie Simpson (My Mother)
For imput towards the edited product,
along with imput towards the final product.

This book is in dedicated to my older brother, *Mark A. Simpson.* All artwork shown in this book, are all original *Mark A. Simpson's.*

This book is a collaboration between two siblings,

Tabatha M. Simpson

&

Mark A. Simpson

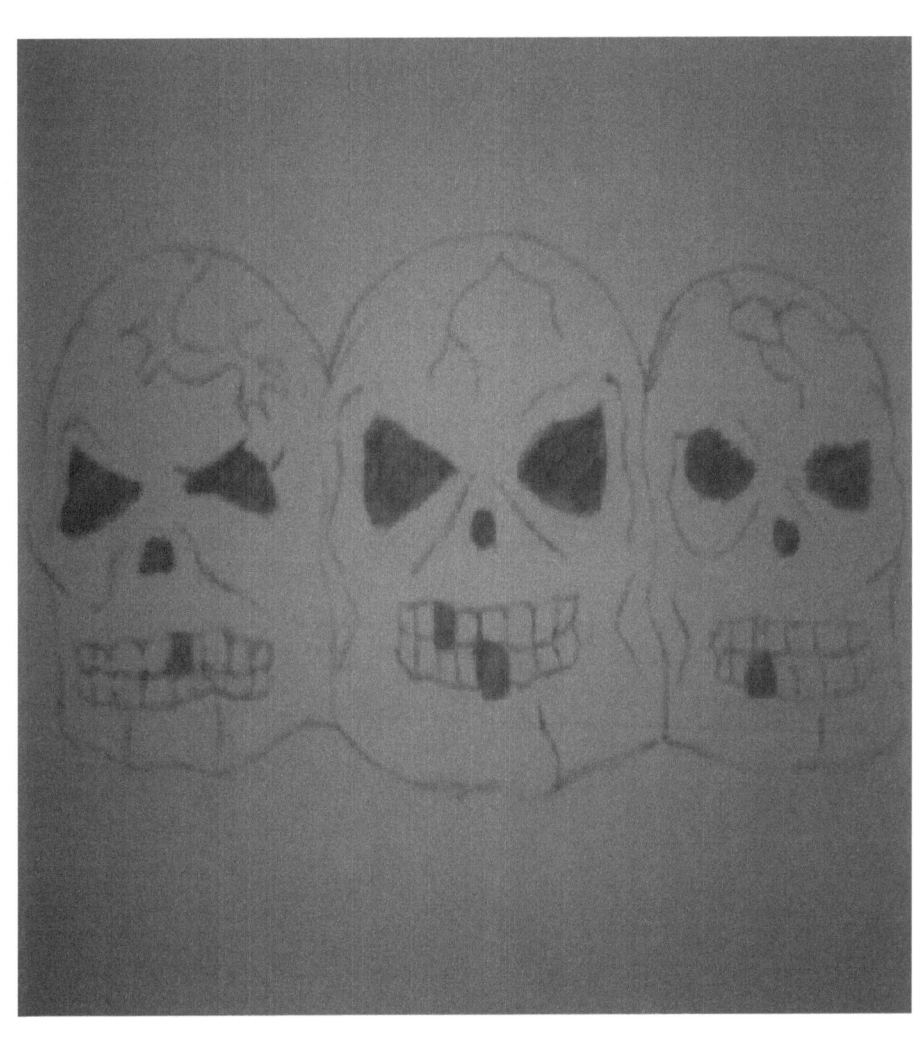

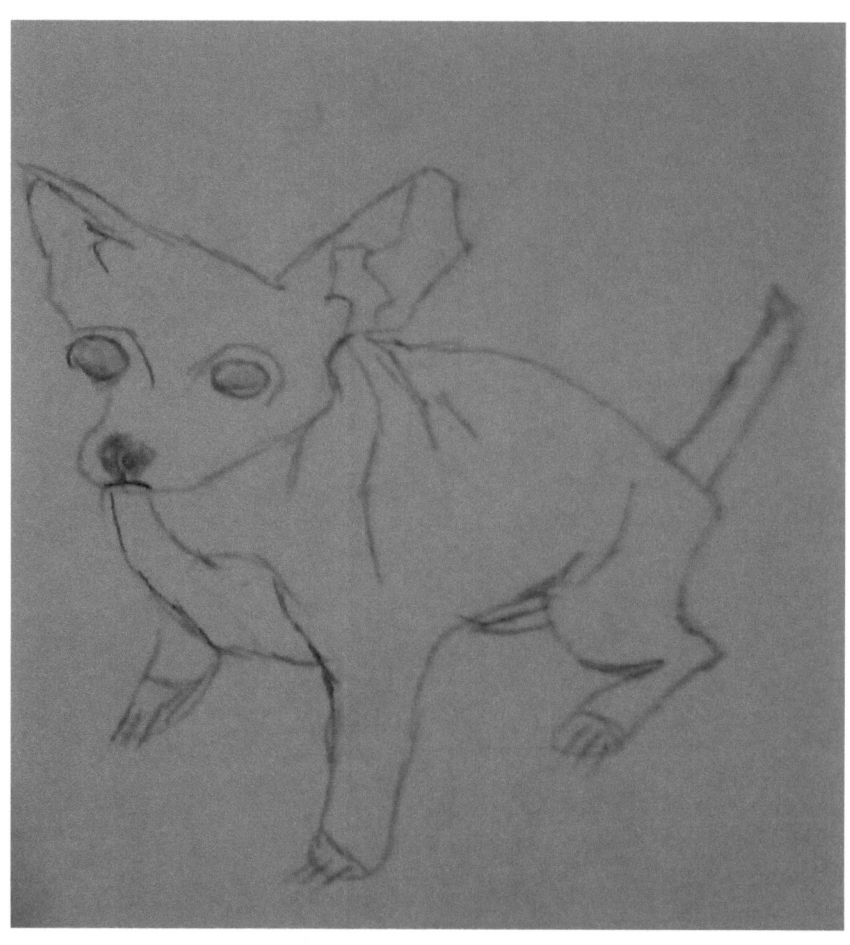

I know this probably looks like the "Taco Bell" dog,

But I guarantee you that it is not.

This is a picture of my younger sister's and her fiancé's dog Ashley.

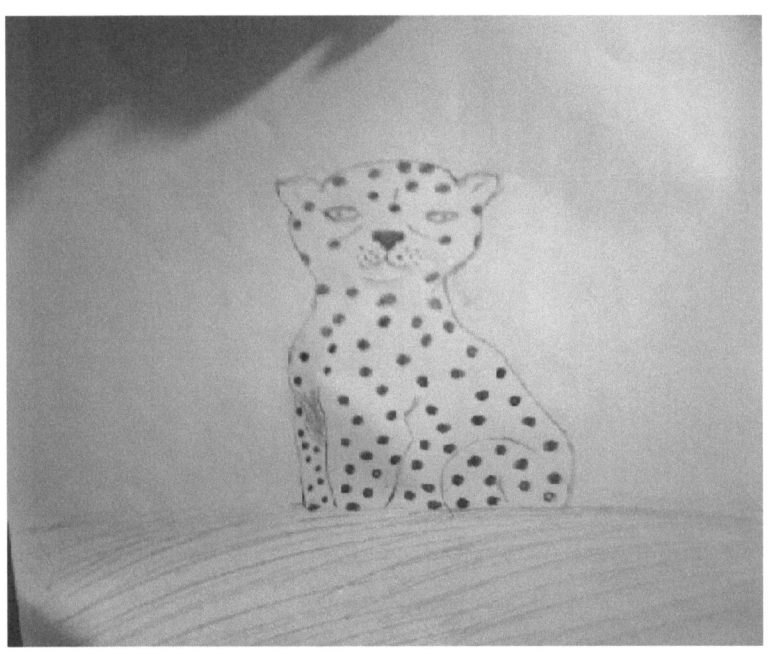

I like this picture, but the thing about this one is,

That I got my inspiration for this piece,

From a lotion pump that sets in my room,

It was a gift. When you push down on said pump,

It growls and sound exactly like this particular style of cat,

And my mother and younger sister,

Are constantly pushing down on the pump.

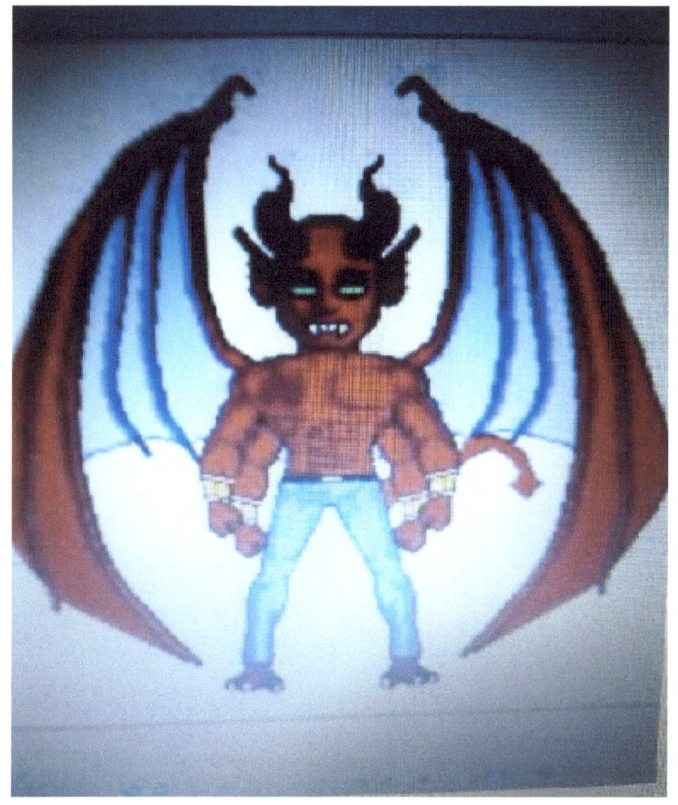

Out of all of my art work,

This one by far is my absolute favorite!

I,

Not very long ago got into digital art using a computer,

And this is one of my pieces of art work from that.

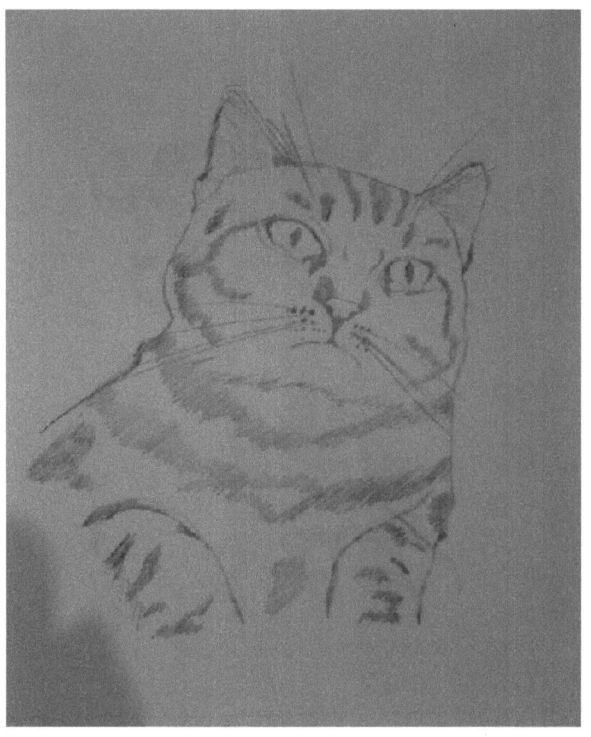

This is my cat Jasper.

He was just hanging out on the dining room table,

And somehow my sister got him to sit still so this drawing could get done.

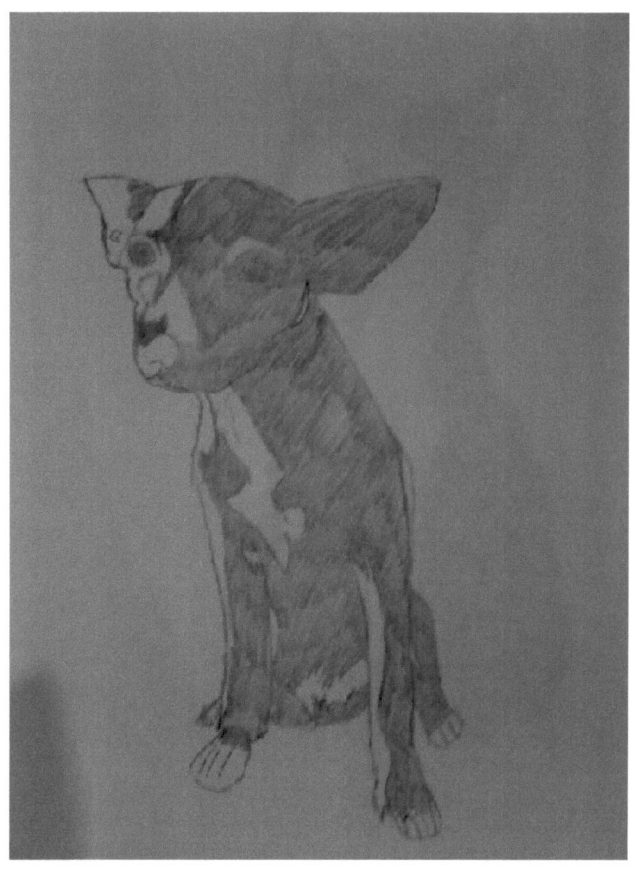

Introducing my dog, this is Leayah. She is the best little dog I have ever had.

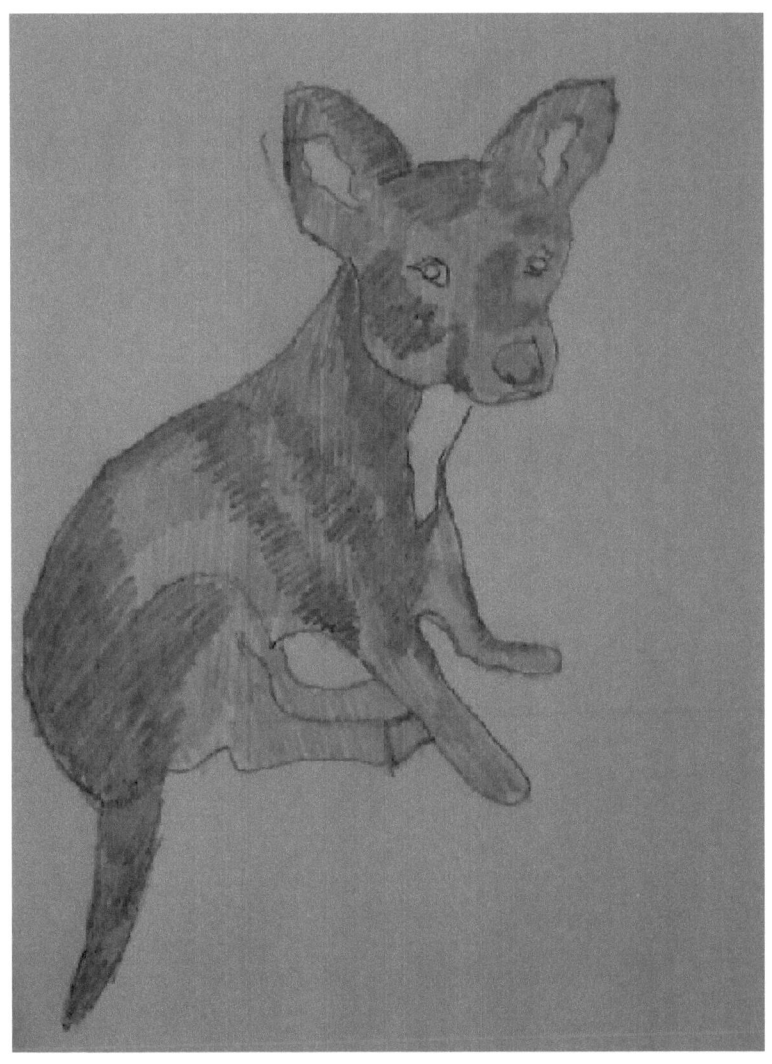

I think that this is one of my much better drawings of Leayah.

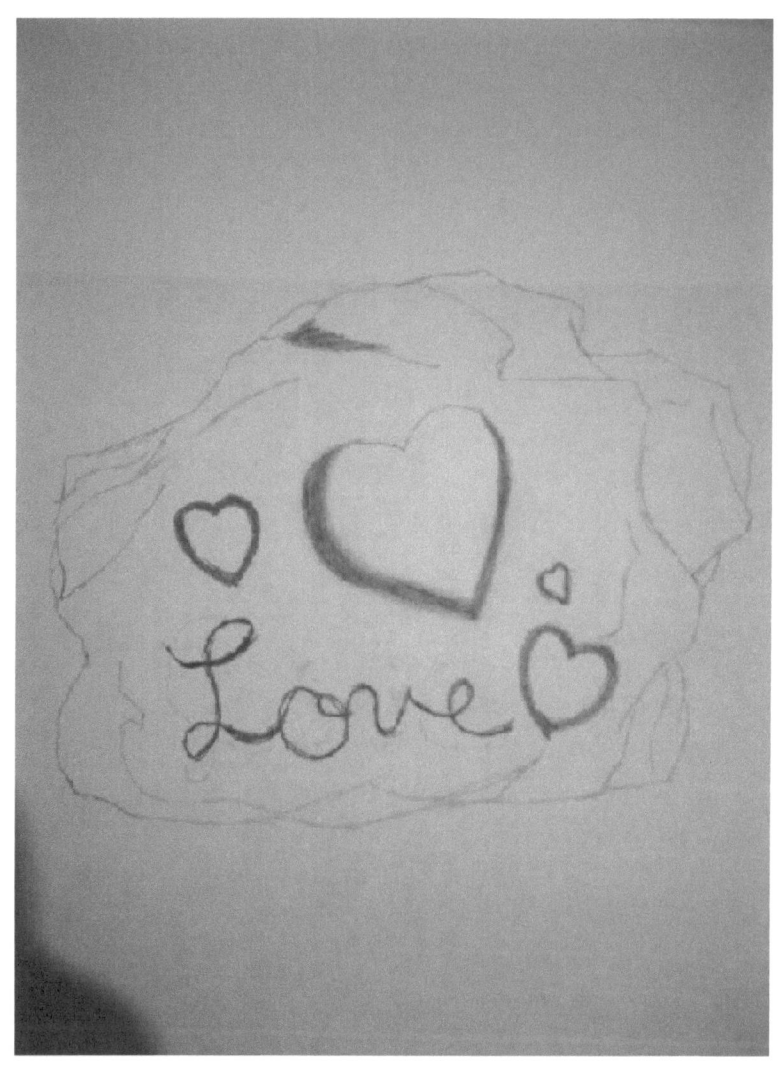

Love stone. Need I say more?!

R.I.P

George R. Beck

November 1923-September 1991

Captain at the El Cerrito Kensington Ca Fire Department

This one may be a bit blurry,

But this is a drawing I did a few years back of my papa

(Grandpa Beck) and it is now framed in my house.

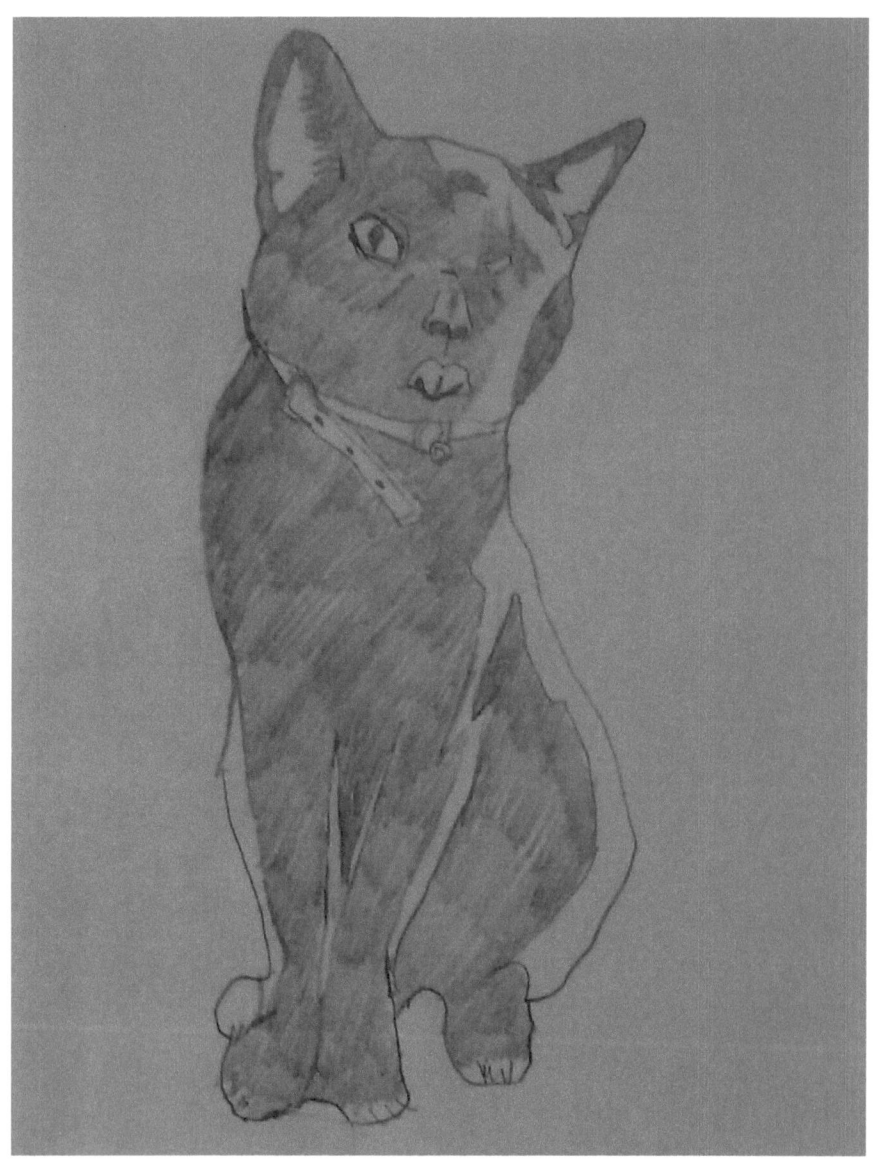

This is my younger sister's and her fiancés cat, Precious.
He decided that he wanted to stick his tongue out for this picture.

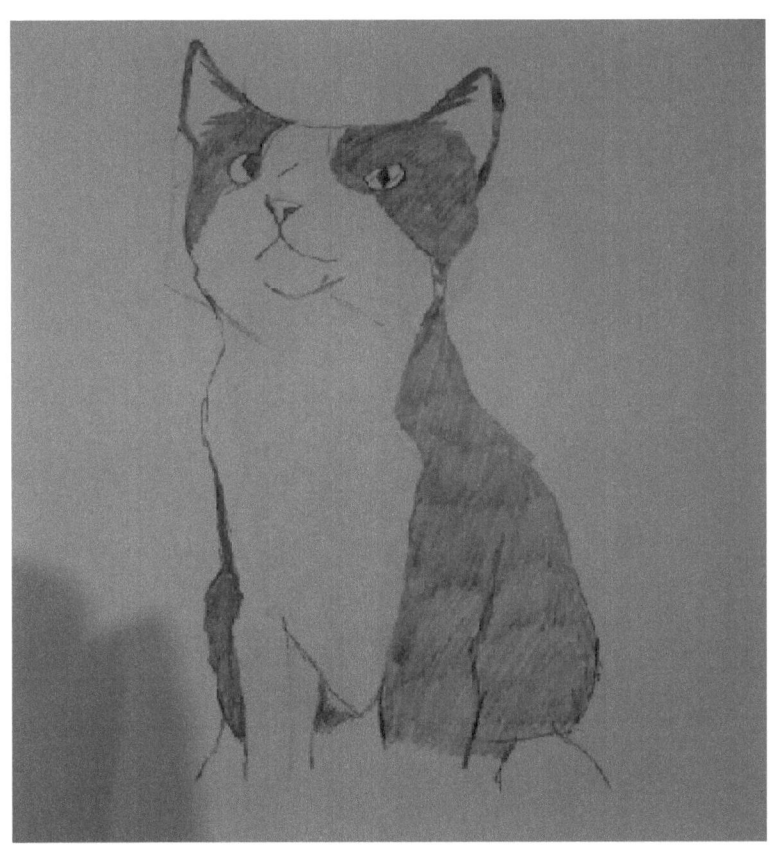

This is my younger sister's and her fiancés cat Rascal.

They have had this cat for eight years and trust me her name definitely suits her,

Because she really is a rascal.

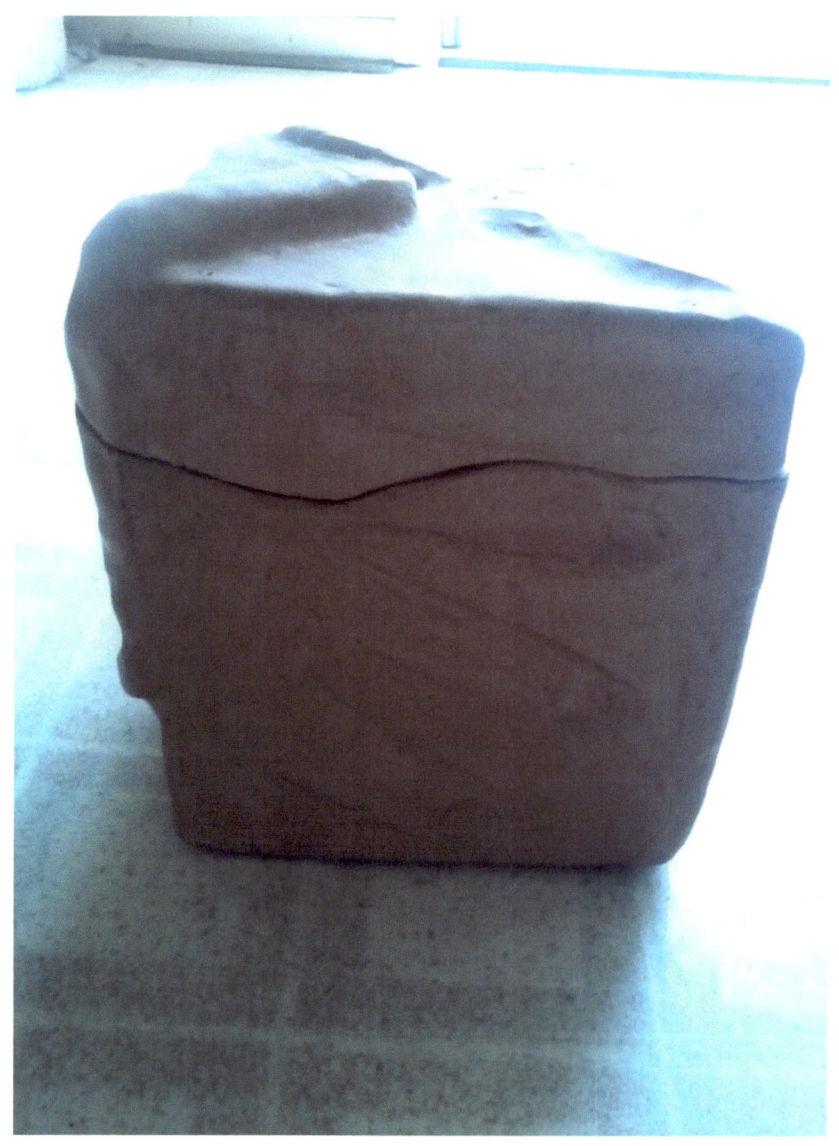

This is a ceramic piece I did. It may look like an ordinary ceramic box, But when looked at closely you can see my actual handprint.

Now, this one is one of my favorites and took the most time to create. This is a mask I created.

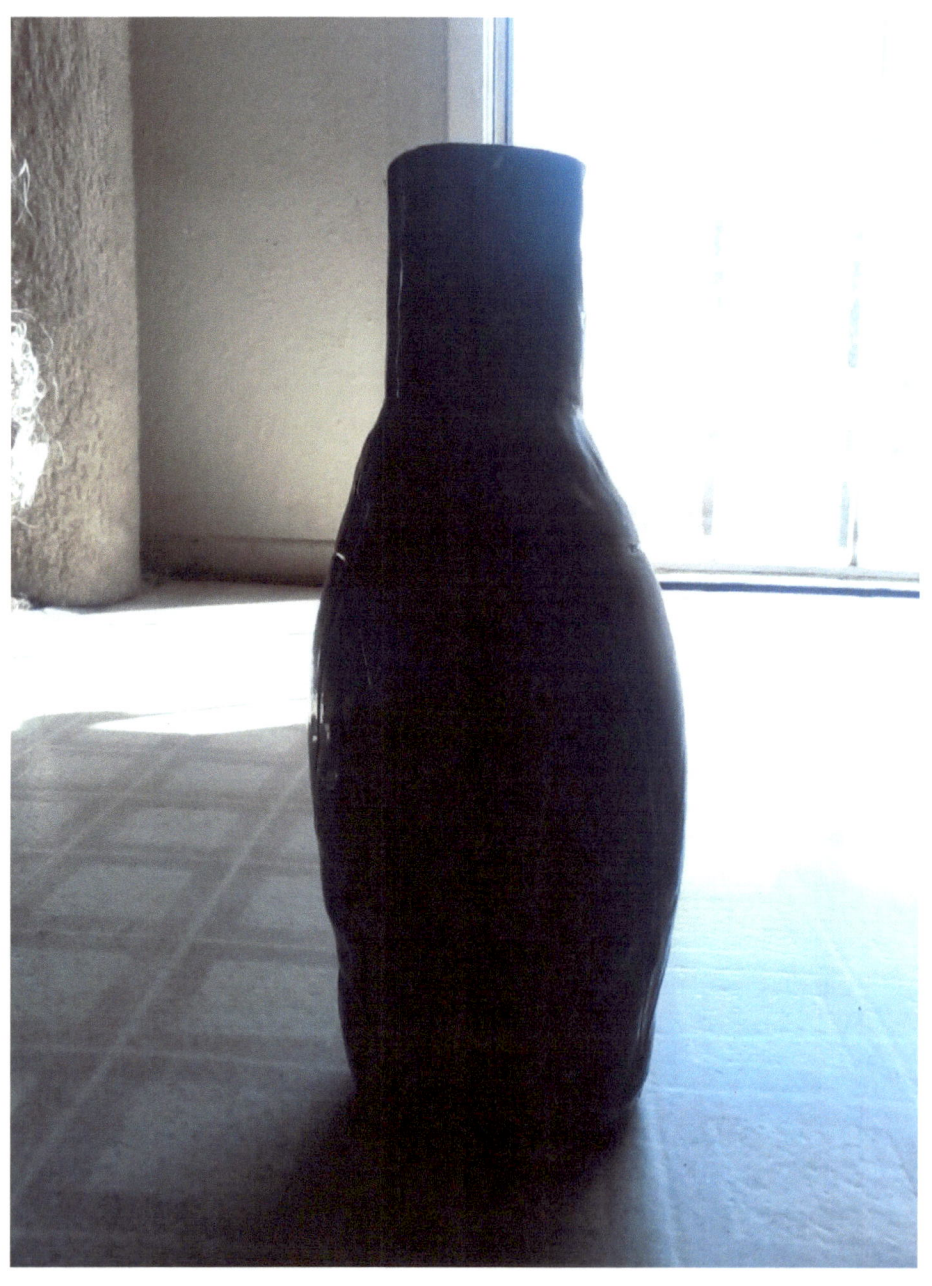

Silverish, shiny vase, that I created by hand of course.

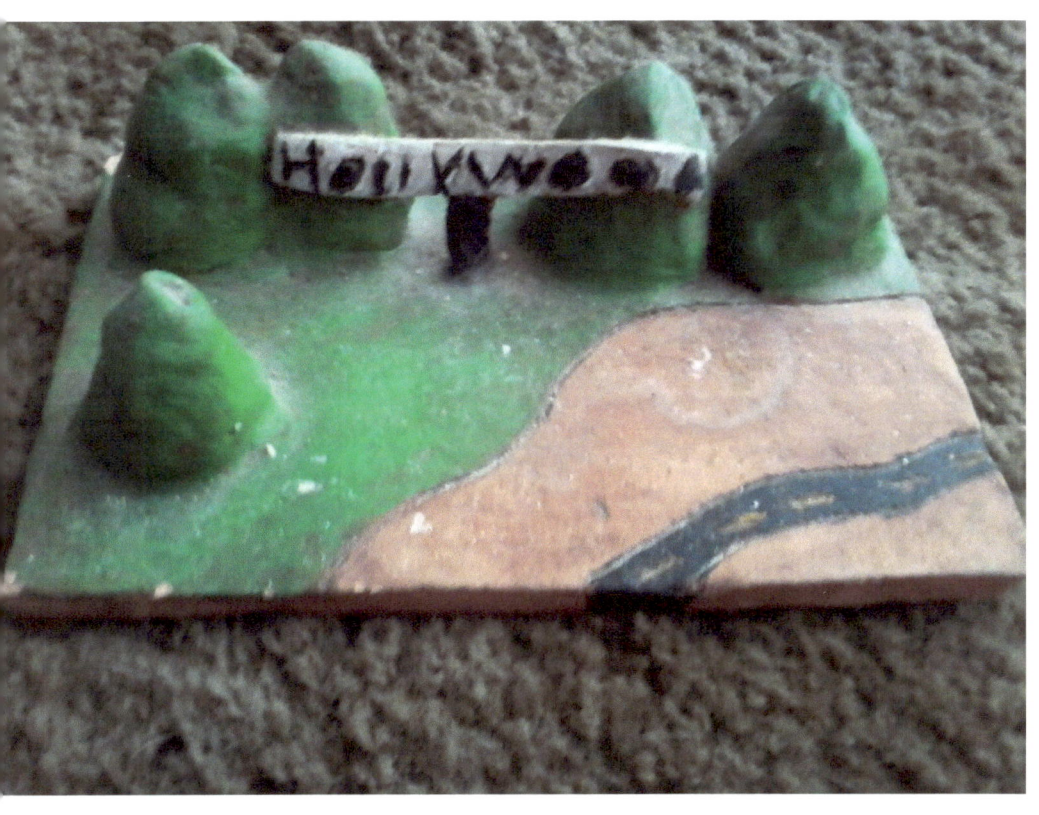

Doesn't everyone want to go here sometime in their life?

This is just a little piece I did and gave it a Hollywood sign.

Let it be noted that:

"No, I am not trying to copy Hollywood

nor claim that this is how it looks or ever looked.

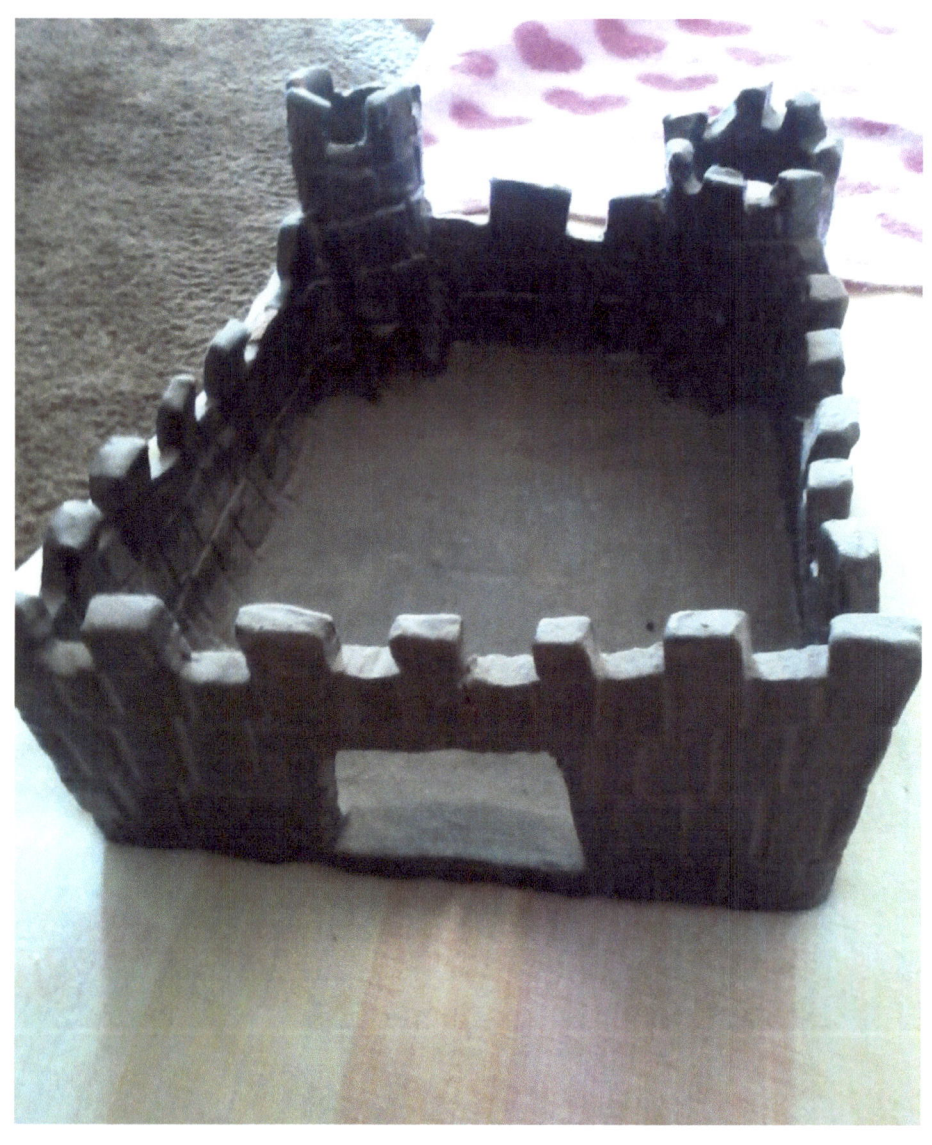

I call this one "Castle".

This is one of the first pieces I ever did…

Using ceramics.

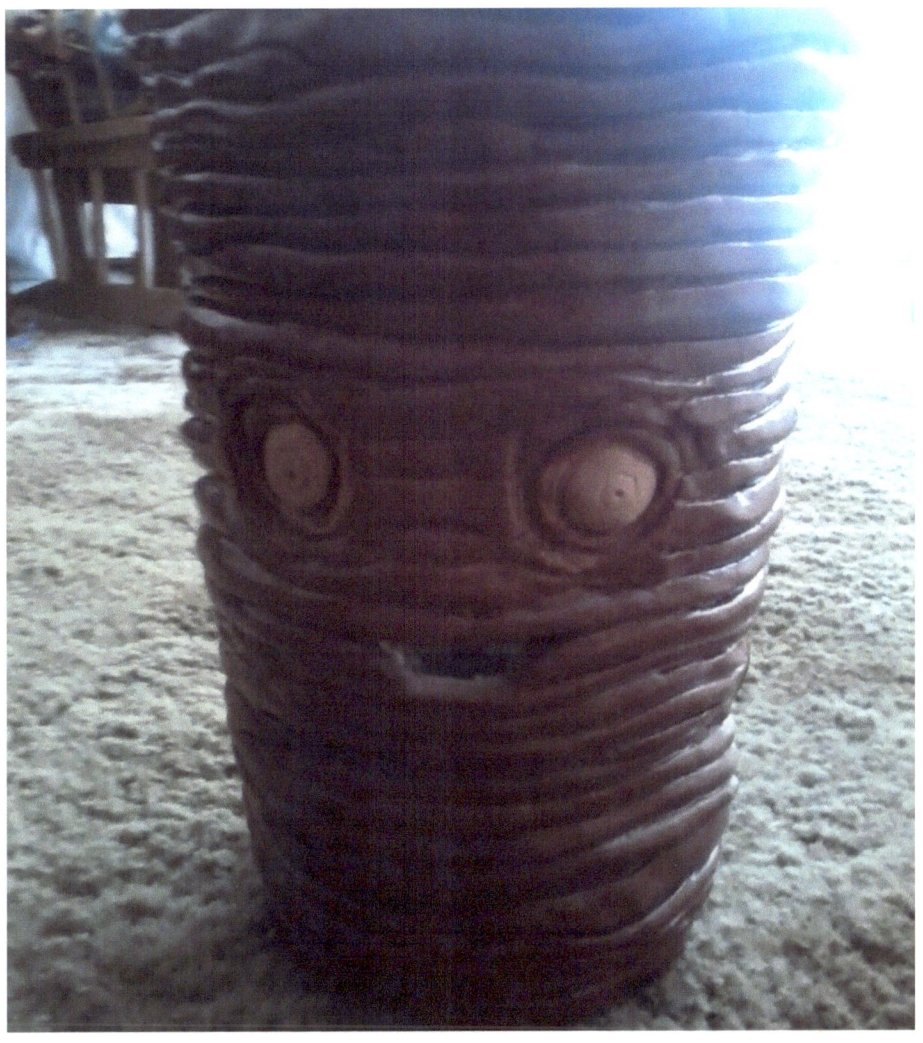

Spiral, Smiley Vase

There is not much I can really say about this one,

Except that I had fun making it.

Its name speaks for itself.

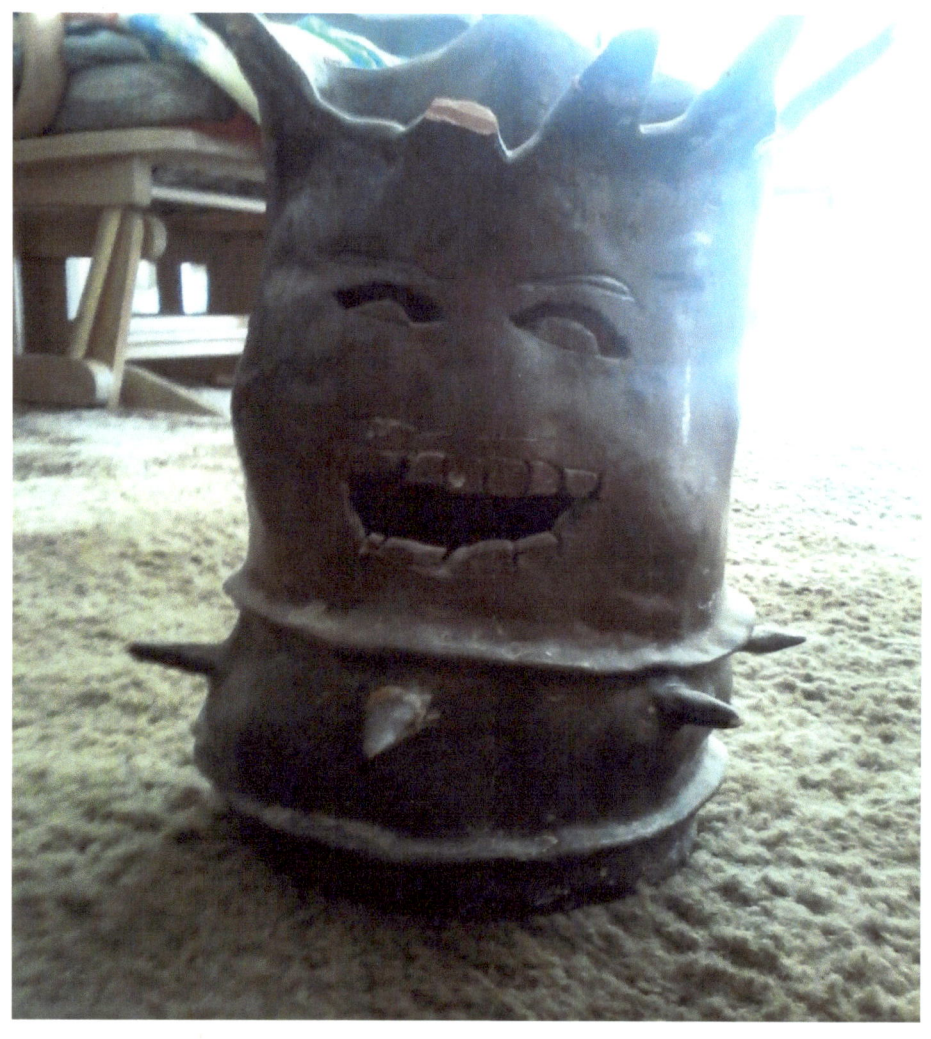

This vase has more of a "punk" type feel to it.
I like it. It is just another smiley vase.

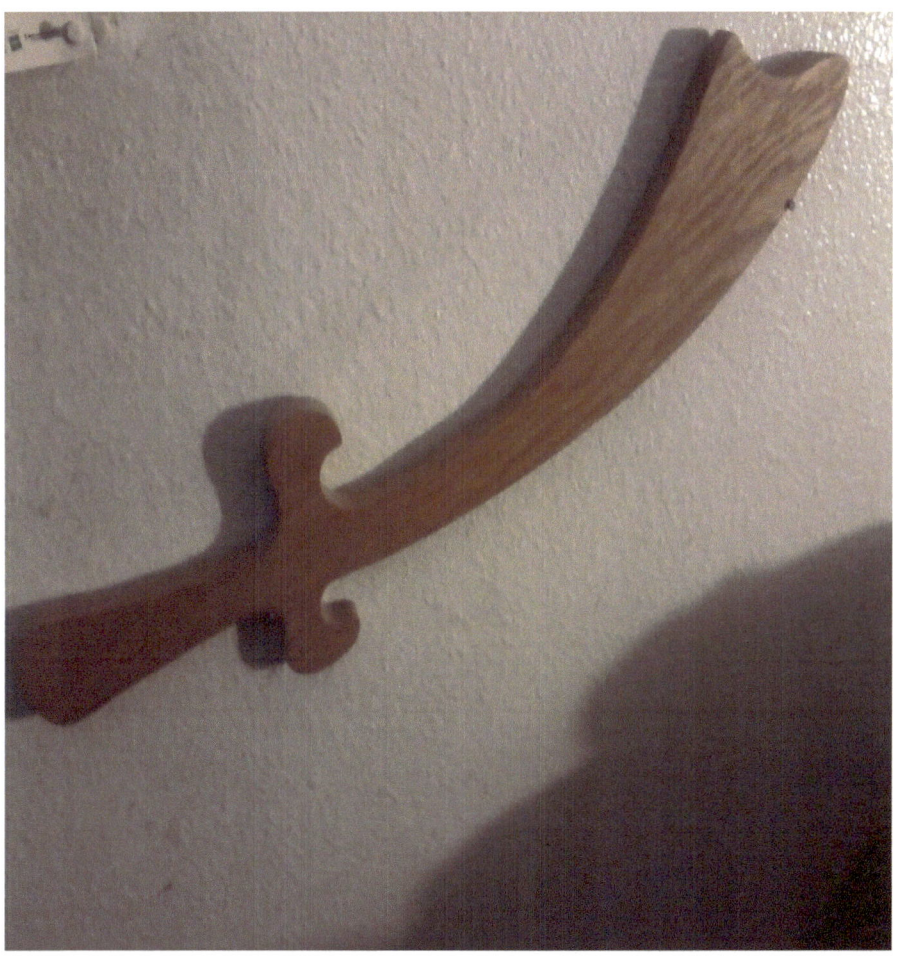

I really like this sword.

It took a lot of time and frustration but I finally got it done.

This currently hangs on one of the walls in my house.

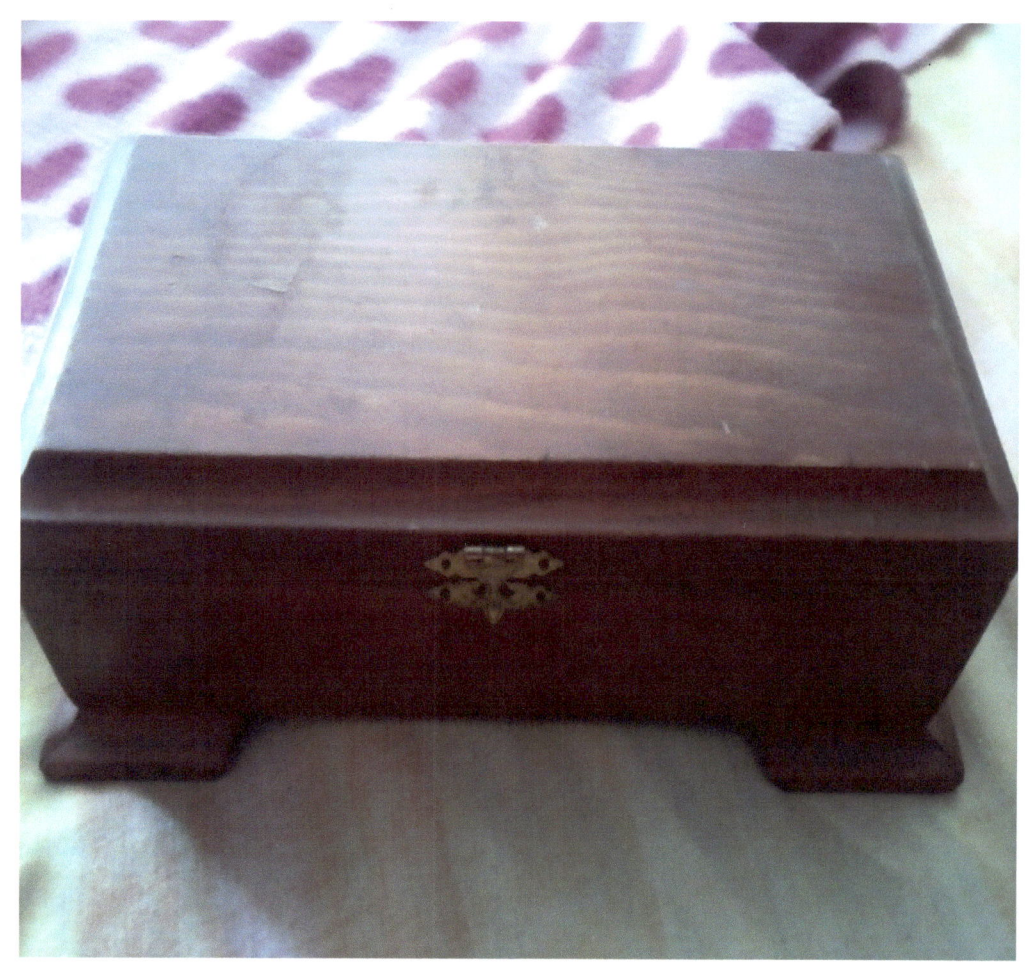

I created this jewelry box in woodshop

And gave it to my mother as a gift.

She has used it ever since.

TO BE CONTINUED…

WELL

WE WILL HAVE TO WAIT & SEE…

WONT WE?

www.ingramcontent.com/pod-product-compliance
Lightning Source LLC
Chambersburg PA
CBHW041122180526

45172CB00001B/374